EPILOGUE OF POETS

Edited by

Andrew Head

First published in Great Britain in 1998 by
POETRY NOW
1-2 Wainman Road, Woodston,
Peterborough, PE2 7BU
Telephone (01733) 230746
Fax (01733) 230751

All Rights Reserved

Copyright Contributors 1998

HB ISBN 0 75430 511 2
SB ISBN 0 75430 512 0

FOREWORD

Although we are a nation of poetry writers we are accused of not reading poetry and not buying poetry books: after many years of listening to the incessant gripes of poetry publishers, I can only assume that the books they publish, in general, are books that most people do not want to read.

Poetry should not be obscure, introverted, and as cryptic as a crossword puzzle: it is the poet's duty to reach out and embrace the world.

The world owes the poet nothing and we should not be expected to dig and delve into a rambling discourse searching for some inner meaning.

The reason we write poetry (and almost all of us do) is because we want to communicate: an ideal; an idea; or a specific feeling.

Poetry is as essential in communication, as a letter; a radio; a telephone, and the main criteria for selecting the poems in this anthology is very simple: they communicate.

Epilogue of Poets is a collection of poems that carry many messages. Some detail a strong opinion on subjects which inspire, while other poems bring to our attention just how delicate spring can seem in its majestic form to a poet.

Every subject that has been unpicked by poets through the ages have been given a new chance to flower before the reader's eye and create a picture of intimacy between both reader and poet.

Epilogue (meaning closing speech) of Poets is an enticing collection of poetry by well established in-house poets and poets who are making their debut.

Enclosed between these pages are reflections of poets' thoughts, feelings and emotions. I'm sure you will find it an inspiring and uplifting read.

CONTENTS

		
A Word	Carl J Carew	1
A Boy On Remand, Dwaine	Yvonne Brewer	2
To A Very Dear Friend	Rebecca Carlton	3
Full Love	M B Such	4
The Wood Carver's Ideals	Lee Fish	5
Garden Of Light	Susan Carr	6
Closure	Aine Mellon	7
Summer Longing	Jillian Mounter	8
The Dwelling	Jeff Jones	9
Loving Sweethearts To The End	Wayne Lloyd	10
My Little Retreat	E Cox	11
The Sailor And The Young Boy	R Marr	12
Country Girl	Keith Large	13
Poppies	Philip C Winter	14
O' Dear Old Ulster	Donna Watson	15
Morning Sounds	Christian Barry	16
The Sea	Patricia A M Lawson	17
Revelation	Craig Walker	18
The Storm	Dusty Sutherland	19
Untitled	Mary Taylor	20
Wheels In Motion	R Tweedy	21
Gemma	Alan Grainger	22
Ode To Diana	Alan Nell	23
Smoke	Michael Kennedy	24
The Milkman	Carole Amer	25
Night	W Robertson	26
Rain Without Sunshine	Lee Sutherland	27
Confession Of Love	Lauren Grace	28
You Are All	Geraldine Doherty	29
Untitled	K Walsh	30
Freedom	J Robinson	32
Memories	Nancy Dawson	33
Time To Remember	Mary Hogg	34
Jilted	Ashleigh Jane Fletcher	35

When Stars Fall . . .	Anne Twine	36
Friendship	Matthew Sawl	37
Moonlight Flittin'	Julie Anderton	38
The Daffodil And The Rose	John Garrett	39
Little Miss Perfect	Doris Johnson	40
Misguided Concern	W A Place	41
Love	Deborah Butler	42
My Pixie Friend	Margaret Lee	43
The Fisherman's Lament	Dave Ireland	44
Somme	R Moore	45
Barrow Deep Lock On River Soar	John Smark	46
My Private Goodbye	Johonna Rowley	47
Despair	William Holden	48
Beautiful Dream	Sarah Wiseman	49
Caprice	Andrew Langton	50
Growing Up	Miranda Lee	51
Concentration	Daphne Prewett	52
When The Laughter Ends	Pauline Tattersall	53
Special Place	Belinda J Howells	54
Sights In Our Country	Alwyn James	55
After The Snow	Damien Mallon	56
Lost Nursery	K J Long	57
The Birth	Phyllis Dawson	58
Where Art Thou Guiding Light?	Suzanne Lewis	59
If Only	Mary Shepherd	60
The Farmer Today	Ian McTeir	61
That's The Wonder Of Love	Robert Jennings-McCormick	62
Romeo And Juliet	Victoria Jayne Barnes	63
Thousands Of Stars	Alex Fittes	64
The Journey	J R Griffiths	65
Darkness	M Stovold	66
Diana	G A Isaac	67
Untitled	Sylvia Tate	68
Kerry	Vincent McLeod	69
Untitled	J Sharrock	70
The Circus	Judith Cutter	71

		
Holiday Blues	Kerry McGee	72
My Son Matthew	Linda Woodhouse	73
As Changeable As The Weather	Jean Hendrie	74
In Its Spell	K Lake	75
To Be Ashamed	Alan Green	76
Eternal Flame	Denise Shaw	77
The Old Indian	Gwyn Thomas	78
Untitled	Jane Murphy	79
This Land Of Mine	David Joseph Burke	80
Berwick-Upon-Tweed	Coleen Bradshaw	81
Don't Quit . . .	Gary Hayes	82
Vicky's Legacy	Magarette Phillips	84
Winter	Sheila Farrer	85
Time Out	Gloria Aldred Knighting	86
Windows	S M H Barton	87
Somewhere . . . Somewhere . . . Sunshine	Ghazanfer Eqbal	88
And *Still* The Blackbird Sang!	Geraldine Squires	89
Living Water	R Powell	90
A Word To A Fellow Poet	Stanislaw Paul Dabrowski	91
A Global Freethinker	Edward Graham Macfarlane	92
Solitary Soldiers	Iain West	94
The Rook	Sheila Aikinson	95
Unsung	Ann Stewart	96
The End	R Wright	97
With Silent Tears	D McKenzie	98
Viagra Fools	Roger A Carpenter	99
I Love There	Ann Beard	100
The Perpetual Grumblers	Alma Montgomery Frank	101
The Light	Keith Murdoch	102
My Lord Abides Here	Colin Allsop	103
Lover's Return	May Strike	104
What We Have	Heidi Michelle Lambert	106
Built-Up Strength	Richard Clewlow	108
You've Got Some Drinking To Do	M Shimmin	109
Not Me!	Marc Hambly	110

Life	Joanne Ellis	111
Painting Pictures	Olive Wright	112
A New Day	Tom Ritchie	113
Sketches	William Price	114
To An Injured Son	Joan Isbister	115
My True Love For Emma	Antonio Martorelli	116
Q10	Jean Mercer	117
Eleven Thirty-Three	T G Bloodworth	118
A Donation We Give	Brian Marshall	119
My Dungeon	Kim Montia	120
Road Without End	David Goudie	121
Samuel The Octopus	Lord Ciaran D'arcy	122
Priceless Gift	Sally Slapcabbage	123
Do You Know?	Roy H Fox	124
The Castle	Janet Parry	125
Memories	Sharon Davies	126
A Special Party	Sheila Ingham	127
Halcyon Days	Gordon Haines	128
On A Cool Winter Morn	Lillian R Gelder	129
Wicked Ways	A Khan	130
The Old Cottage	G P Silver	131
Sunflowers	Sam Edwards	132
Our World	Alan Brooke	133
Poetical Aspiration	P Openshaw	134
Mulling	Tina McCarthy	135

A Word

Go, go -
Roll away into the soft pink mist,
Don't say a word of what you saw;
Nor careless whispers of the
bloody show,
The innocence lying battered
bruised in the gutter,
The loud city life
notices nothing,
Life passes by - then
slips away,
Go, go -
Roll away into the soft
pink mist,
Remember - Don't say A Word.

Carl J Carew

A Boy On Remand, Dwaine

I want to get out, let me go home
Someone hear my cry
I am sitting here trapped in a cage
And all I want is to be with my mates.

Life is not real anymore just a pretence
I live in a place surrounded by a fence
The crime was bad and got out of hand
Now I have to accept that sentence as I stand.

I know I did wrong but I can't change it now
I dread the court and foresee a row
He said he was my mate and I believed that
Now he's grassed me up and stabbed me in the back.

I want to get out let me go home
Someone please hear my cry
I feel so empty, scared and alone
Do I really have to wait till the years go by?

Where is my girl - she doesn't call
I'm fed up, want to leave this place
But I guess I have to do the time in this case
In this place, here surrounded by the wall.

I feel so sad I dread the cell
Away from home without my mates
There can't be a worse place or perhaps hell?
I can't see my girl or other dates.

Yvonne Brewer

TO A VERY DEAR FRIEND

I have known you now for just a year
the feelings are strange, not the norm
but why do I feel like this for you my dear
I don't know love in this form.

I could never tell you how I feel
it wouldn't be right
but I know these feelings are real
and they gave *me* quite a fright

Am I silly feeling like that
I wanted to be around you all the while
is loving you, really bad
if you knew you'd run a mile

I don't know why and what it is
it is different; it just feels so right
I ignored it first but I had to give that a miss
Now I have accepted it without a fight

If I would tell you how I feel
that would be the end
you would think I'm not for real
and I would lose my dearest friend.

Rebecca Carlton

FULL LOVE

These thoughts are inscribed
As the dogs of war, were let loose;
And innocence was still abroad.
In World War two, a lifetime past.
Love is blind they say,
No! That is not true.
For love is God
And all the universe,
The creative force, that made you.
Some think love is,
What others think is lust.
For those who understand
Or those who read, and do not.
Pure love, is finer than stardust.
When human atoms cease to war
A better understanding is the score.
Where friendly people can be friends, again!
Suspicion, doubt and fear, cannot win, or
Stay pure love's; full sway.
For this is and every day, *full love.*

M B Such

THE WOOD CARVER'S IDEALS

The shapeless block has life,
Though now restrained, unseen,
Autistic.
I knock with care,
To see who answers.

It is with satisfaction I see
That I have given life,
To that which had none.

Lee Fish

GARDEN OF LIGHT

Next time you're weary or feeling alone,
come see the beauty that goodness has grown.
In a garden where flowers grow without cease,
self-seeded by love and bathed in His peace.

There's pansies for thoughts that are selfless and true,
lilies of peace and forget-me-nots too.
Honesty grows there, upright and strong,
and love from the roses just floats you along.

Whatever your favourite, you'll find it there,
as you stroll in the peace and become so aware,
that nothing of goodness will come to naught,
not the smallest smile nor humblest thought.

For all plant their seed in His garden of light,
and grow in His love, to bloom and delight.
So come to the garden, whenever you're low,
come, see the beauty *your* goodness helps grow.

Susan Carr

CLOSURE

I saw you that night through the smoke and the cloud,
But I was just another face in the crowd.
You didn't even glance as I walked by,
You didn't notice me no matter how hard I tried.
I had admired you for so long, from a distance,
But you didn't think of me, not for an instant.

The day I waited so long for it came,
You walked up to me and asked me my name.
We went out to dance you held me close by,
I felt so happy I thought I would die.
The kiss was so tender, just like I dreamt,
To you it was nothing, but to me, that's not what it meant.
I loved you so much but you thought it was a game,
I felt my heart jump when I heard your name.
You treated me badly again and again,
My heart was broken, I thought I'd never be the same.

You never even loved me, you just used me when you were lonely,
Now we're not even friends.
Now I'm telling you I'll not be there for you to toss aside
without a care.
I now love someone else and he loves me a lot,
I thank God I lost you, because now look what I've got.
You hurt me so much but I'm glad that you've gone
It wouldn't have lasted at least not for long.

I never thought I'd meet someone like him,
He loves me for me and not for what I can give.
You're no longer my love, you didn't believe it but it's true,
He's kind, sweet and he loves me, He's nothing like you.
So I hope you're happy being alone but free,
I hope some day you'll be as happy as me.

Aine Mellon

SUMMER LONGING

Oh to be up on a hillside green
On a glorious summer day!
With not a single main road to be seen,
And the work place far away,
And silence all round, calm and serene,
Save the farmer cutting hay

And the song of the birds; and the lovely view
Would consist of fields, and they
Would have in them wheat and animals too.
Trees would line the winding way
Of the river's banks, and the houses few
Would be picked out in gold and grey.

Beautiful flowers I would see,
More beautiful than in May,
Wonderful scents would be all round me,
More lovely than I can say.
Oh, this is where I would like to be
On a glorious summer day!

Jillian Mounter

THE DWELLING

Does a 'Highmead' have a low
Or a 'Bellaire' have a beau
Does 'Monrepose' offer peace and quiet
'Dunroaming' would suggest
That they have found their final rest
And simply wish to stay there until the end
'Seaview' is rather nice
Though depending upon the price
Providing of course, you can see view
We have not progressed a lot if we still live
In 'Treetops'
Though the comfort has improved I am sure
If a house by any name
Is not a home then who is to blame
It cannot be the agent surely not
Who then can it be
Perhaps the family
Who are not entirely happy with their lot . . .

Jeff Jones

LOVING SWEETHEARTS TO THE END

Remember me as you pass this way
for in your heart and dreams I will forever stay
with a smile on your lips and a song in your heart
I will forever be your darling sweetheart.
Even in death and two worlds apart
I will forever be your childhood sweetheart.

Let us recapture our childhood love
with a song a red rose and a snowy white dove
I will move Heaven on earth and great mountains above
to pledge to you darling my undying love.
When death comes and takes you from my sight
I will still love you with all of my might.

Fire and brimstone hell on earth
I will pass through them all and remember
the love that between us we birthed.

Wayne Lloyd

My Little Retreat

I sit within my garden
And slowly look around
At the many lovely pleasures
That spring from a piece of ground

The grass so green and healthy
Sweet honeysuckle fills the air
With roses dancing in the breeze
As I sit here without a care

My thoughts are interrupted
By a blackbird's song so sweet
As a butterfly goes swiftly by
So peaceful is this retreat

The sound of a passing aeroplane
Casts my eyes to the sky
And there I take in the splendour
Of the sun with clouds passing by

The air around me feels so clean
As I sit there for a while and dream
Of a world I see without suffering and pain
Then I awake and come down to earth again

The sound of a car, the cry of a child
The wind getting stronger, blowing wild
My garden now darkens, as rain clouds appear
As the rain starts to fall pitter patter I hear

But no raindrops can dampen
The pleasure I have found
From sitting in my garden
With such wonder all around.

E Cox

THE SAILOR AND THE YOUNG BOY

Said the sailor to the young boy
Do you see the sea?
That sea you see holds a fascination for me
I've been all around the world
And I've crossed the great divide
I've sailed the many oceans
So broad, so deep and wide

I've been ashore in many lands
And I've heard so many tongues
I've seen so many customs
Strange dresses and odd modes
My head has spun, my tongue has gone dry
Through sailing those many oceans
So broad, so deep and wide

Said the young boy to the sailor
Then tell me sir. Please do
Of the stories and adventures
That did befall on you
As you've sailed the oceans, so broad, so deep and wide
And of the very fascination
That bewitched your very eyes

The sailor then his tale did tell
And so the boy fell under his spell
Cross leg, he sat on the carpet of grass
And not a word did let pass his lips
In case that part of the tale he should miss
Spellbound, he sat upon the grass
Until the sailor came to the end of his tale at last.

R Marr

COUNTRY GIRL

She evades every city
craves for places more pretty
though her radiant smile
could illuminate any crowded night

She runs into the forest
with an essence of ease
amongst the tranquillity
of the calming trees

She climbs the highest mountains
and is way out of reach
you would never find her
on a claustrophobic beach

The call of the country
is her form of escapism
my desire to catch her
is one of optimism

Her beautiful hair emulates the scenery
of the picturesque country girl she will always be.

Keith Large

POPPIES

On a misty autumn morning
The streets still wet with dew
I stood on Makie's corner
Gazing at the view
Down Fawcett Street I wandered
Still shrouded in the mist
When against the expectations
I saw some children being kissed
It was the metal angel that
Came down from the sky
She said I saw you weeping
I saw you start to cry
She came down from the cenotaph
And comforted them there
She stroked away their tears
And ran her fingers through their hair
She said you'd cry the longer
If only you could see
The reason on that November morn
They strew poppies upon me.

Philip C Winter

O' DEAR OLD ULSTER

(Dedicated to the many Irish men and women who have left Northern Ireland since the troubles of '69)

O' dear ol' Ulster
If I could only see
Your finest beauty
and your bluest seas
Then maybe one day
When I come home
There'll be no blood
and broken bones
No more killings
No more guns
Just you and me
and the morning sun
So dear old Ulster
I'll wait and see
When I meet you
and you meet me
I love you.

Donna Watson

Morning Sounds

Beep, beep, beep, beep,
My alarm going off.
Clatter, clatter, clatter
The post is in.
Creak, creak, creak
My dad is up.
Shuffle, slash, shuffle,
My dad picking up jotters.
Clunk, bang, clunk,
It's bin day.
Broom, broom, bang,
The milk man in his van.
Rattle, rattle, bring,
The wind chimes in the wind.
Splash, slash, splash,
My dad in the bath.
Ring, pong, ping,
My mum coming in.
Squeak, squeak, squeak,
My mum on the stairs.

Christian Barry (9)

THE SEA

The sea was calm and very still
The wind it came and gave it will
The waves they lashed above the sea wall
Now so high and very tall
Looking angry and really wild
Enough to frighten a little child
People they scatter so they don't get wet
Caught in the waves like a net

Now so cold with wind and rain
Your face feels cold and numb with pain
Now to get home in the mad rush
Everyone's running to catch the bus

It's now tomorrow and we are back again
At least it's not cold and there's no rain
The children are playing and running about
They must not wander, I'll give them a shout
With buckets and spades in their hand
They've built a castle with the sand

The children they watch in dismay
Their castle won't stand long not today
The tide's coming in now so very fast
Waves are covering it, it's gone at last
Tears in their eyes they want to go home
So now I'll have to end this poem.

Patricia A M Lawson

REVELATION

Whisper winds your words of sorrow
For the aged lost tomorrow
When the silky soft of your hand
Was not soiled by filthy mankind

Blue sea rage in bitter crashes
For man child's oiled hands in your washes
Effluent in your soul sinking
Crash on you see that no-one's thinking

Heaven's tears to wash the mountain
Feed the spring and summer's fountain
Tainted by the chemist's meddling
To push the chemicals they're peddling

Cry forlornly mists of yonder
Polluted by this age of wonder
Plagues to fog the sight of babies
With man's created earthbound Hades

Scream mighty forest of the ages
Whose heartwood died for penny wages
Raped in slashed and burning ways
To fuel the economic haze

The rain falls acid as a warning
Man's Armageddon self-made dawning
Humanity got cut in rushes
Politicians wonder what the fuss is.

Craig Walker

THE STORM

It started with a gentle breeze
Through the urban street
Rain pitter pattered on the roof
All creatures in retreat
The downpour was torrential
As it flooded in the yard
Soaking all and sundry
With total disregard

Crescendo claps of thunder
Roar across the sky
The tempest raged and ravaged
All that drew it nigh
Branches beat on windowpanes
With rhythmatic paradiddles
An orchestration of the storm
Like untuned concert fiddles

Lightning lit the heavens
An illuminating flash
People stranded in the rain
Made a quick and poignant dash
The storm has now abated
And gone upon its way
Bringing brilliant sunshine
And a brand new day.

Dusty Sutherland

Untitled

The river of life flows on its way
From dawn to dusk from night to day
First as a baby, wailing, crying
Sheltered by mother love undying
Then as a toddler, stepping out
Knowing not what things are all about
Still clinging fast to his dear, dear mother
Thinking that there can be no other
At four years old he goes to school
Where he must obey each golden rule
At eleven he's quite a lad
Burst from the apron strings, so sad
Now he turns to his loving Dad
Cricket and football can't really be bad
At fourteen he discovers girls
He's bowled right over by legs and curls
Studying, playing and sex comes fast
His baby days are in the past
His wedding day, and he is plighted
His mother weeping, his father delighted
Bairns of his own to bring up now
He gets his come-uppings here, and how
Then retirement rears its ugly head
The doctor becomes his friend in need
He tells all his kids about life lived, when
Things were so different twixt now and then.
The bairns laugh it off, as only they can
They really feel sorry for their old man
He keeps going on, until at last
He returns to that river that's flowed too fast.

Mary Taylor

WHEELS IN MOTION

All types of wheels, do all types of things.
Wheels forever, wheels supreme.

Aeroplane wheels, touch the ground.
Passengers home, safe and sound.

Train wheels turn, signals ahead.
Lights change, green to red.

Car wheels turning.
'Watch out,' driver learning.

Flywheel don't hesitate.
Engine speed, to regulate.

Ferris wheel at the fair.
Pay your money, you just dare.

Bicycle wheels, spinning round.
'Peddle away', homeward bound.

Wheelbarrow, help me out.
Garden produce, to move about.

Catherine wheel, it's Guy Fawkes night.
Spin me fast, touchpaper light.

Lottery wheel, on a Saturday night.
How many numbers did you get right?

Millions of wheels will be turning today.
May the 'Wheel of Fortune'
Spin your way.

R Tweedy

GEMMA
(My Granddaughter)

You looked, I looked, we looked,
But your look searched my soul.
As your eyes scanned the very chamber of my heart,
My 'vision' was now clarified,
With the remembrance of my 'lost youth',
Reflected in your innocent eyes.
It was a 'mirror' of my life gone by,
'Is this the 'message' of a granddaughter's gaze?
Is this the 'emotion' born to amaze?
How can I know what makes me see,
The 'love' exchanged from you to me.
You make my eyes look beyond just 'vision'
You are 'nature's child' just risen.
This blooming love shall not fade,
Because you are 'creation' and not just made,
This love we share, will take us far.
In all the 'heavens' you are my 'star'.
Among 'galaxies' of magic light,
You are my 'love' you are my 'sight . . .'

 Bampi . . .

Alan Grainger

ODE TO DIANA

It was a fateful Sunday morning when sadness and shock prevails
The angels above were weeping at the death of the Princess of Wales.
On the brink of finding happiness our Princess met her fate
Along with the man she truly loved, perhaps her future mate.
How could such a thing happen to a lady so sweet and kind
Still her memory will live on forever in everyone's heart and mind
The people turned out in their thousands to watch her cortege go by
And no one present was ashamed for others to see them cry.
For Diana was a special lady with a caring approach to life
For sick and injured children, innocent victims of war and strife
Her own two sons William and Harry to our everlasting pride
Although their hearts were broken, thanked the mourners
 yet never cried.
It could not fail to touch your heart watching them be so brave
As they followed their mother's coffin on its journey to the grave.
There were mourners in abundance in every London street
Showing how British courage adversity can meet.
So we shall say goodbye to our Princess, as the tributes still increase
To the best-loved Royal of them all - Diana rest in peace.

Alan Nell

SMOKE

Standing at the edge of the cool dark woods
Summer is almost over.
They call me here to contemplation
I don't smoke now!
When my age is nearly done, I could try some
Yes! Here at this very spot leaning on this tree
I think! Night will be fine
All those stars to dream-shine.
Time rolls on to seasons changing
I did come back, after all, I'm here now
At last, leaves have fallen before me
Wind-blown snow covering paths leading to Never-place!
This must be the end
And I throw it down to the ground.
My campfire shows its smoke to the air
When that dies away all hope is lost
and the moon shines.
The lake turns ice-cold.
The night is left shimmering as the stars light up
The moon still, in the black
must shine, shine, shine.

Michael Kennedy

The Milkman

I know a worker,
His name is John,
Before you're up in the morning
He's been and gone,
He's a milkman if you
Haven't guessed,
While you're still in dreamland
He's just getting dressed.
He'll hurry along with his
Bottles and crates,
The wind and the rain is the
Weather he hates.
But I'm one customer who'll
Make him happy for life
I should know because I'm
His wife.

Carole Amer

NIGHT

The sun sets behind the hills
And twilight turns to dusk
Ten thousand stars stud the sky
Each one of these a heaven's eye
To gaze upon our earthly night
For them a never ending sight
A fallen star is like a tear
An omen for our earth to fear
Prediction of some coming woe
High floods or deep drifting snow
She shoots her light on high
To scarcely ever lie
The yellow moon then rise
To hooting owls' cries
Who find their day in night
With hunting silent flight.

W Robertson

RAIN WITHOUT SUNSHINE

Though the love still burns strong within,
Smiles I once had,
Have all crumbled away,
Upon my face lays a frown.

Without you there's no sunshine in my life,
Days drown out with the rain,
The nights cold and lonely I begin to cry,
Just throw some love my way,
I'll be your everything,
Give me a hug along the way,
Arms wide open providing all your needs.

Lee Sutherland

CONFESSION OF LOVE

If I were a bird
sitting up in a tree
would I fly down
and sing for thee

Or would I get scared
and off I would fly
Gliding and soaring
Across the dark night sky?

If you were a bird
sitting up in a tree
would you fly down
and sing for me

Or would you fly away
and run like the rest?
Should I hide away
or face the test?

I am so afraid
that my heart will break
Should I confess to you
for love's sake?

Lauren Grace (13)

YOU ARE ALL

You are the future, the present, the past,
You are the middle, the first and the last,
You are in all and all is in you,
You are my voice and all that I do.
You are the people of everyday life,
You are her father, her sister, her wife,
You are my rainbow in drizzling rain,
You are the causer and killer of pain,
You are my day and you are my night,
You are my darkness and also my light,
You are my sunrise and my sunset,
You are my guidance and safety net.
You are my land and you are my skies,
You are the sparkle in lovers' eyes,
From my words you can probably tell
As long as you are all, all will be well.

Geraldine Doherty

Untitled

I spent nearly all my life
Being a caring mother and wife
But did you know throughout your life
How much I really loved you?
When you were small, I'd watch each day,
As with your toys you would play
But not once did you hear me say
How much I loved you.
As you got older, you treated me good,
I felt just like a queen probably would
But did you know like you should
How much I really loved you?
Now I am old, and starting to miss
The times each night you gave me a kiss
 and said goodnight.
Oh, how I wish, I'd said how much I love you
I think of you every day
I love you more than words can say
With all my heart I pray some day
You will hear me say
I really, really love you.
We think of you often your dad and I
And the pain gets worse as years go by.
Every morning, each day of the week
Your dad gets up and to your photo he speaks.
His kind of grief, he has never shown
It's locked inside until he's alone,
Then he talks to you of the love he had
And tells you he's proud to have been your dad.

Times have changed in this human race
And he hopes you have found a much better place
Where you have all the things that you never had
And you'll always be happy instead of sad.
And maybe some day if God wishes it so
United we'll be when it's our time to go.

K Walsh

FREEDOM

If history does repeat itself
We should hang our heads in shame
For some of life's atrocities
We really are to blame.
We turn our back on some things
Not wanting to get involved
But if we tried to stand our ground
Some crimes could be solved.
Long ago we had black slaves
And kept them locked in chains
They were badly beaten
Ignored of tears and pains
And now we say it's in the past
Those days are dead and gone
Can we say it's really true?
Do some things still go on?
Is it really over?
Is compassion something we lack
Or do we still tend to say
You can't come in here, you're black?
We should be able to live together
We all should have one voice
To make the world a better place
For all to have freedom of choice
So let us be joined in unison
And all of us work together
For freedom for everyone in the world
And those chains be broken forever.

J Robinson

MEMORIES

Down the lane of memories
I slowly wend my way
Thinking of my childhood days
And the games we used to play

Those golden days were endless
The sky seemed always blue
My mind looks back to those happy days
And the friends that I once knew.

I remember the dear old village school
Our mistress dressed in grey
I was scared if she just looked at me
How changed things are today.

But still they were such happy days
And though she would sometime scold
Beneath that grim exterior
There beat a heart of gold.

Though memories can sometimes cause heartache
There are happy memories too
These are the treasures locked in my heart
That will last my whole life through.

Nancy Dawson

TIME TO REMEMBER

I have but a short time, to live upon this earth
While I'm here, my mind is filled
With wonder, of such beauty I see
Feel around me to ponder upon,
With a slight breeze blowing through my hair;
Kissing my lips, fine salty sea spray,
Seagulls flying overhead, displaying swift flight.

Fly high little birds, fly away now
Towards faraway places, I've never been
You have the world from which to choose
Yet! Here you are flying high around me,
For a while I shall linger
To catch this early morning dew,
At the edge of our world I wander
along, alone but for you.

Wondering how long this peace shall last -
My mind, and soul as one;
In tune with the wind, sea and birds
I'll hold onto every moment's venture;
Hoping memories like these
Will weather life's storms.

Mary Hogg

JILTED

How will you spend this wondrous night?
Oh, golden angel, full of life;
Shedding teardrops in my room,
For one who'll never be my groom,
I cry alone, for him alone,
My feelings have intensely grown,
For him and only him to love,
Forsake all others in heav'n above,
But no return of love shows he,
A heart of stone is shown to me,
Another object takes his time,
And he shall never, ne'er be mine,
I take my life for he will not,
In hell, I feel, I shall but rot,
Dead in both my soul and life,
For he forsakes me as his wife.

Ashleigh Jane Fletcher

When Stars Fall...

When stars fall,
And the aching loneliness of a winter's night
Glitters around me,
I will miss you.

When the sea sighs,
And saltwater tears dash against
The sands of time,
I will weep for you.

When birds fly,
Bursting through clouds of gold
To the sun,
I will wait for you.

In sweet rain,
With the amber mists of autumn
Glowing to a haze,
I will dream of you.

And at the end of Time,
When dreams of Heaven explode
In celestial light,
I will find you again.

Anne Twine

Friendship

It is trust and understanding,
That makes a friendship true.
Always giving and forgetting
Being honest too.

Harmony is what we seek,
A circle never ending
Closer and closer to each other,
Relationships are mending.

You are my brother,
The reason I'm here,
There will be nothing between us,

No fear.

Matthew Sawl

Moonlight Flittin'

'Get down from the cooker our Granny
You know that you can't ride the range.'
But as much as those wise words were told us
As kiddies we thought they were strange

Until later in life a large family
Who lived in a house up the road
Was helping some friends near to bedtime
Move a very unsteady large load.

There was Mother and Father with children
And Grandad looked forward t'th change
And there on the top was the cooker
With their Granny a'ridin' the range.

Julie Anderton

The Daffodil And The Rose

Wild winter's body possessed by spring
whose primrose yellow face
breaks the earth with its first flower
then falls to midnight dust
as the daffodil is born
whose long stem grows
and trumpets Welsh defiance
to the violence of the weather.

Born and bred in summer sun
the rose within its crown of thorns
that speaks of love and valentines
and struts at Chelsea flower shows
this English country gardener's dream
of frail and false perfection.

Unlike the fickle precious rose
which rules within its garden walls
the daffodil
the banner of our birthplace
paraded proud on castle greens
and grassy banks deep rooted
grows truth, sings freedom.

John Garrett

LITTLE MISS PERFECT

What's the score with poor little Miss Perfect
Did she finally fall through the hoop,
Find the further she flew she had more things to do
'Til one day she went loopety-loop?

'It's so sad, it's so tragic,' they whispered,
Smiling smug little sniggers of spite,
For nobody liked poor Miss Perfect
So they watched her demise with delight.

It started when she was a tiny,
Pretty princess who played pretty please,
Who warmed Momma's heart as she acted her part
In a game we'll call happy families.

But now she stands stranded bewildered,
For she's always done just what she's told,
But they missed out the twist in the perfect prize list
When another princess joins the fold.

So now she must try to fly higher,
Better battle to beat all the rest,
But a little voice whispers inside her,
'You'll drop dead just keep doing your best.'

And it's suddenly clear in the spotlight
As the scales fall away from her eyes,
She never was meant to be perfect
'Twas enough to be simply alive.

So slipping away from the contest
Smiling, 'Goodbye you do or die group,'
She catches a snatch of the latest newsflash,
'Where's Miss Perfect? Gone loopety-loop.'

Doris Johnson

MISGUIDED CONCERN

I was sitting at home quietly the other Friday night,
When Marlene rang Mary to say, there may have been a fight.
Marion her sister had declared earlier, trouble was abrew,
So when they gave her a bell, they couldn't get through.

'Quick! Alan dearest, you must dash round posthaste,
As their house in Windermere, may have been laid to waste.
You must go and check if John and Marion's alright,
There is something amiss cos we can't contact them tonight.'

So I intrepidly set off to find out the score,
What was I to be confronted with, maybe blood and gore.
I approached the house cautiously, saw it still in place,
After a loud knock, was greeted with John's smiling face.

'Whatever can the matter be?' I asked Marion and John.
'Your sisters are worried stiff, fearing that you're both gone.'
John said, 'The phone was out of order and we've informed BT.'
I said 'That's all's the matter, they're as worried as can be.'

They insisted I must not go, without my New Year's glass.
Then she got out the Hennessey, cos she's a right canny lass.
After John and I supped a fair amount of exquisite brew,
I set off back home but the road seemed to slew!

When I finally got back home, Mary had found out from BT.
Just as well, cos I'd forgotten all about her, you see.
The moral of this tale is simply misguided concern,
But as it turned out their regard did me a good turn.

W A Place

LOVE

Please don't hurt me anymore, I just can't stand the pain,
It's so unfair that I'm the one with all the heartache once again.
My confidence is shattered, my self-respect has died.
My mind is so mixed up and a thousand tears I've cried.
So now I'm building a wall with a 'no entry' sign across my heart.
I also need time to heal, only I don't know where to start,
As you've taken away all I ever had, my independence
and my pride.
You've also turned me into a stranger, a stranger who wants to hide,
So please don't come my way again bringing all your pain and sorrows
I really would rather be on my own for today and all of my tomorrows.
You see I really have had more than my fair share
Of falling in love with people who don't really care.
Now I'm searching for my inner strength, then I'll make you see
That no matter how hard you try - never again shall you hurt me.
Just stay away, please leave me alone
I really would rather be on my own.

Deborah Butler

My Pixie Friend

At the bottom of my garden,
underneath the hedge,
I have a little pixie friend,
and his name is Reg.
This is my little secret,
because if you see him there,
he'll get cross and nasty,
and then he'll disappear.
He lives inside my dolls' house,
but no one knows he's there.
You see he is my special friend,
and knows just how I care.
I bring him little titbits,
whenever I get the chance,
Sometimes he comes out to play,
and we'll have a little dance.
He has the cutest little face,
and is happy as can be.
He wears a red and yellow suit,
if only you could see.
But no, I mustn't tell you,
for that would be the end,
Then I'd never see him,
and I'd miss my little friend.
He's such a lovely pixie,
I hope he's here to stay.
I love him very dearly,
and hope he never runs away.

Margaret Lee

The Fisherman's Lament

Bright and early up with the lark,
Flask filled, going out whilst still dark,
It's fishing I'm going I drive to the place,
Darkness now going, I see people's face,
Water is smooth, flat, and very calm,
I feel the impulse to try my arm,
Get tackled up and comfortably I sit,
Shotted up, ready to go, this is it,
Casting out into the calm, 'I wish'
Away slides my float I'm into a fish,
Feeding maggots need to get out there,
Got to stand up, get out of my chair,
Throw a little harder to reach, I think,
Mud very slippery damn I fell into the drink,
Up to my neck in a freezing cold river,
Got to get out I'm beginning to quiver,
This was my third trip, no fish I had seen,
Unlike some others I had two 'big bream'.
Must get out it's bloody cold in here,
Pack up my tackle and home for a beer,
My young son came with me to learn what to do,
I certainly showed him a thing or two,
Out of my clothes, then into the bath,
Reflecting on the day, *we all had a good laugh.*

Dave Ireland

Somme

The mist hangs over the battlefield as the wounded soldier lies
In an air of cool tranquillity amongst the dying's cries.
He looks up to a smoke-filled sky then to the blood-red soil
As black crow feeds on still warm corpse oblivious in its toil.

War had come he heard the call and went to serve his king
Joined up with the boys about his age in pride his heart did sing
And as they marched down to the dock and boarded on the boat
The cheering crowd sang their goodbyes a lump came to his throat.

As they made their journey, on a chilly autumn night
Stars in the sky spread before them a wondrous heavenly sight
The ship cut a swathe in the inky sea the spray so cold and damp
And moon up there in God's great sky like a jewel in an angel's lamp.

All charged with apprehension, they alit onto the shore
Young bodies shook right to their souls as they heard the cannon roar
As they went to their destination pockmarked by bomb and shell
From the green fields of their homeland they marched straight into hell.

They took their places in the trench on a field they called 'The Somme'
And on that day many lives were lost from bullet, shell or bomb.
Then came a great explosion a massive direct hit
Bodies thrown into the air and hurled across the pit.

The soldier shed a silent tear as he lay among the dead
Blood gushed down his anguished face from a hole upon his head.
He pondered on the senseless waste let out a mournful sigh
And closed his eyes one final time as he waited there to die.

And as he lay there waiting he heard a joyous cry,
A host of golden angels alighted from the sky
They bore him to the heavenly gates and took him through the door
He'd never have to fight again another pointless war.

R Moore

BARROW DEEP LOCK ON RIVER SOAR

Fishermen as one drew in their lines
When they heard a distant humming.
It meant their sport would stop for a while
They knew a canal boat was coming.

Round the river bend the boat appeared
And to the river bank did glide.
With engine cut and stationary
A little time it now would bide.

As they arrived at Barrow Deep Lock
Two men and a boy leapt ashore.
To get to the next canal would mean
Rising up from the River Soar.

Gently gliding 'neath Barrow Lock Bridge
Canal boat lazed into the lock.
Gushing water Canal met the Soar
The boat rose with grace and did rock.

With the waters now about equal
The Canal boat patiently waits
For the men who so recently left
To put backs to the large lock gates.

Straining sinews until something gave
Inch by inch the lock gates parted.
To leave the Soar to explore some more
Canal boat's engine it started.

John Smark

MY PRIVATE GOODBYE
(Sandra)

They gave her two days or so they said
It was like waiting for a green light change to red
The hurt in her eyes, her pale shallow skin
Who knew what pain she held within.

Why was it her, oh! God tell me why
And couldn't you pick someone else to die?
Hands almost perfect but nails almost grey
Please raise up and wipe my tears away
I miss you already before you go
I love you so much, in hope you know
A breath and a sigh as you drift in your sleep
Time to say goodbye my love, my memories to keep.

Johonna Rowley

Despair

When you have no dreams,
when you cannot plan
When you have no job,
what becomes the man?
When you stay abed,
when you have no say
When you have no money,
to take a holiday
When you have no reason,
to plan for future years
When you can only
relieve yourself in tears
When your old alarm clock,
becomes redundant too
When you wear your last year's clothes,
you can't afford the new
When every day is Sunday,
each and every day
When you have the time to waste,
your life is sure to pay.

William Holden

BEAUTIFUL DREAM

A night on the dance floor
Music clouds the air
Many passing strangers flow
Making you feel so alone there
Lights flash all around you
But sight now becomes blind
As the strong arms surround you
Feeling safe, warm and kind
Whilst the cold-hearted look on
Melt into this passionate life
With one who knows nothing
Of painful cuts of the knife
Just one request before dying
As the ending of night draw near
A kiss on lips so beautiful
The band plays on to your fear
Never to be forgotten again
Goodnight to a love unknown
That sweetest perfection gone
Nothing left but to go home.

Sarah Wiseman

CAPRICE

A second glance at an old nightmare:
First impressions and no words written.
The same faces caught on camera;
The same unanswered question.
An obsolete obsessive
Stood throwing stones
At egg-shell perfection.
Isolation for a four-letter word;
Humanity encapsulated in cliché,
Too caught up in each other
To survive to save themselves.
Living for a wasted alcoholic dream,
Dreading the terror that arrives
With the realisation of truth.

It is easy to be soothed by cool lies
And a caressed betrayal.
Calmed by kisses and amnesiac affection.
A life of ignorance and compromise
Deception and forgotten promises,
But I am lonely and lost without you.

Andrew Langton

GROWING UP

Once I was a baby,
Who made my parents glad.
Now I'm growing up at last,
And sometimes make them mad.
Now I am a schoolboy
And go to primary school.
Playing with other children
Sometimes I act the fool.
Sometimes I say and do things,
That makes the teachers cross,
But I always try my hardest,
Knowing who's the boss.
I always try my hardest,
And try to do things right,
But sometimes things get out of hand,
And ends up in a fight.
Mummy likes me when I'm good,
But boys are only boys.
They all get up to mischief,
When they get fed up with toys.
I love my mum and daddy,
And I know they love me too,
So I try my hardest,
To be good in all I do.
I know I can be naughty,
But you know what boys are like,
Because I'm growing up real fast,
I've got my own real bike.

Miranda Lee

CONCENTRATION

As I wander through my memories,
(this is something I like to do)
If I concentrate hard enough
I know I'll picture you
standing there before me
with that lovely smile
looking like you used to do
although it's been a while.
I feel your arms around me
and snuggle up so near
you whisper that you love me
and there's nothing for me to fear,
we talk about so many things
why it was not meant to be
that we grow old together
for all eternity,
then you start to fade away
my concentration's gone
but in my heart and in my mind
your memory lives on.

Daphne Prewett

When The Laughter Ends

Laugh loud my friend
in the face of foes
Laugh at life and
all it throws
Laugh as the knife
is slowly turned
And laugh as revenge
is yours in turn.
Laugh as you're dealt
the cruellest hand
Let your laughter ring out
through all the land
Laugh as you brush
away that tear
That somehow slipped through
your hard veneer.
Laugh when your heart
is torn apart
And laugh as the stone
is cast
Laugh and the world
laughs with you
For he who laughs
last - lasts.
But what when the laughter
ends my friend?
When your laughter tears
run dry
When all that once
seemed laughable
Will one day make
your cry.

Pauline Tattersall

Special Place

In that place, that secret place
I saw your lovely precious face
That day you held me oh so close
I though of that hard wooden post
As I saw your wounded side
I thought of all the times I'd lied
Then I saw your pierced hands
I thought of all my selfish plans
I saw the scars of the crown of thorns
Of how you'd suffered from lips of scorn
I wondered if I'd have done the same
Would I have run not played the game
Could I have given what you did
Or would I have in the closet hid
As your children we badly fail
We take our time to cry and wail
But your our Master and our King
Your Holy Spirit convicts of sin
In that place, that special place
I see your face your precious face.

Belinda J Howells

SIGHTS IN OUR COUNTRY
(Montgomeryshire)

Travelling through this precious county,
along its narrow winding roads.
Cloaked by hanging hawthorn hedges,
shelter for sweet whistling birds.

I often see a sly old fox,
or a bobbing rabbit's tail.
Hopping swiftly to the safety
of the land beyond the rails.

Buzzard hovering, wings vibrating,
a tasty morsel in its sight.
Spot that half-grown scuttling badger,
dark eyes wild and filled with fright.

Sheep and cattle grazing freely,
simply sprinkled in the fields.
Hosts of brightly-coloured flowers,
swaying gently in the breeze.

Golden wheat that cloak the meadows,
proudly standing on parade.
Glistening streams meander calmly,
heron fishing as they wade.

These are sights that gladden hearts,
that brighten up one's life.
Creatures running wild and free,
untouched by hand or human strife.

Alwyn James

AFTER THE SNOW

Once the sun's long fingers
sign with broken branches
on your whitened palms
you understanding go,
undressing, slowly at first,
the newly verdant pastures,
leaving white reliefs
only in sundial shadows,
behind the hedgerows
departing drifts shelter
like piebald gypsy ponies,
leaving one by one,
while we're not looking.

Damien Mallon

Lost Nursery

The sunlight streams through the window,
And lights up the dust on the floor,
The echoes of long past laughter,
Can sometimes be heard at the door.

All the teddies are lined up like soldiers,
The dolls' house is empty and still,
No more do the toys come and go here,
Long past is the time when they'd thrill.

The rocking horse creaks when you rock it,
Its paint is all faded and worn,
And all the toys are so very lonely,
They miss their friends who have gone.

The sunlight streams through the windows,
And lights up the dust on the floor,
Nothing's changed since the days it gave pleasure,
But children don't play here anymore.

K J Long

The Birth

In the place of birth, a stillness pervades
A sense of anticipation, as the moments tick by
Eager hands wait to receive another life
About to enter the world with a cry
Conceived from a union of love's embrace
The waiting, while the body within a body
Comes to full-time and journeys to an unfamiliar place
No more protected by its mother's body
The dark comfort of the womb forever past
Unconscious of the pain it inflicts upon another
Little by little it struggles towards the light at last
And finally emerges to become a separate being
The revelation of two lives become as one
While the mother gazes in wonder at the new-born child
The moment long awaited, has at last come
So through the ages the cycle of life goes on
Each generation reproduces its own likeness
To each some joy, some sorrow, life will bring
As it travels its chosen path its own destiny fulfilling.

Phyllis Dawson

WHERE ART THOU GUIDING LIGHT?

I saw the star that was supposed to lead me . . .
It was motionless, as motionless as me.
Was it a faith I wasn't sure I had,
Or had I lost sight of reality?
The rain, it cleanses inside then out.
A motion of calmness from the silhouette of darkness,
The alternative that lies before me
But not distinguished enough to recognise.
The bells chime their calls to those who are invited,
A guest list of saints, a faith so strong?
But still I am going nowhere because my star will not move.
Immobile to the senses, a headache which begins.
Yet I can stay still, until the urge becomes too strong.
I can stay still until the end of all time, if that's what it takes.
A time when God sleeps in peace, an unrestrained peace,
While his angels look on in silence.

Suzanne Lewis

IF ONLY

If only, just two little words we often use each day
but such a depth of meaning those two words convey
If only we'd said this or that instead of which we said
the very first unruly thought that came into our head

If only we had put ourselves in that other person's place
we would not now be wishing that we could hide our face
If only we had thought about the money that we spent
we would not now be wondering how to pay the rent

If only, just two little words that signify regret
bringing many sleepless nights with minds that are upset
So let us always stop to think before we do or say
then those two little words will not be used today.

Mary Shepherd

THE FARMER TODAY

The farmer sows his seed in spring
Also time for the birds to sing
Ploughs up some of his ground
Where many a stone can be found.

With his harrow breaks up the clods
Round the fields he does not plod
Scatters the seed and rolls it in
The growing process does then begin.

Harvest time soon comes along
By now the birds are in full song
Wanders alone to the middle of his field
That's him checking his yield.

In days gone by he needed many a hand
Mostly now gets by with just one man
Progress they call it and moving with time
What's your thoughts? I know mine!

Ian McTeir

THAT'S THE WONDER OF LOVE

That's the wonder of love -
That makes your eyes glance
When hearts start pounding
And you walk in a trance

That's the wonder of love -
When it softens your heart
Proclaiming through life
That you're never to part

That's the wonder of love -
When - not another will do
You walk in daydreams
All - of your days through

Keep the prize so precious
Hold it within your soul
Let the angels surround it
In Heaven you will stroll

To the everlasting pleasure
Of the greatest gift so far
The wonder of love is glory
Splendour - It's - *Wunderbar*

Robert Jennings-McCormick

Romeo and Juliet

Two families that do not see eye to eye,
Two youngsters in love that are destined to die,
Montague and Capulet who are not at peace,
Romeo and Juliet whose love has to cease.

Romeo is banished and Juliet distraught,
All because Romeo and Tybalt had fought,
Tybalt was killed through Romeo's scorn,
And now both the families are all quite forlorn.

Juliet invented a plan with the friar,
So Romeo would come back and quench her desire,
Unfortunately the friar's message couldn't get through,
To warn Romeo of the plan and what he must do.

He went to Verona to Juliet's side,
Drank a bottle of poison and wrongfully died,
Juliet then awoke from a very deep sleep,
And couldn't believe who was laid at her feet.

She then took a dagger from Romeo's side,
Stabbed herself once and unfortunately died,
Now both lovers are buried together,
To rest in peace forever and ever.

Victoria Jayne Barnes (15)

THOUSANDS OF STARS

Thousands of stars
One full moon
Sitting looking out of the window
Thinking what could be happening
Somewhere else
What could they be thinking
at this moment in time?
I wish I could know.

Alex Fittes (10)

The Journey

Sunrise motivation breathes, as the wind echoes,
over the hills and through the trees.
In a desolate space, one heart too numb to cry.
Reading between the 'lines', she only wanted to say
goodbye.

Out of the valley into the pale ivory sky,
as a bird on the wing flies so high.
Silently listen, never far away.
My senses tell me, you are gazing over by day.

Time stands still for a little while.
Reminisce with a faint smile.
Fragrant fragments linger from your freedom flight,
while stark frail emotion, dimmed our room to candlelight.

Sunset, regret, sympathise with our grief.
Your inspiration allows new belief,
as time steals and heals with one hand.
Take a safe journey to the promised land.

J R Griffiths

DARKNESS

In the darkness I can see you, lying on your bed,
In the darkness I can see, those thoughts that go
 through your head.

When I woke up in the morning, I dreamt that you were gone,
But then you touched me and I knew nothing was wrong.

As I pulled back the drapes, I glanced back at you,
You were sitting up in bed by then, you looked at me just
 as if you knew.

You knew that I was leaving, tears filled my tired eyes,
So I turned towards the windows, and clouds that
 filled the skies.

Just then you kissed me, you never said a word, so
I left the room that morning, never to be heard.

M Stovold

Diana

Such beauty's not been seen before
Now, sadly, she is here no more.
For millions all around the world
Unparalleled sadness is unfurled.

That dreadful crash, that fateful night
Which took our Princess from our sight
Hit too the family Al Fayed
With Dodi taken from his dad.

Romance it seemed was very clear
To each the other was so dear
Cruel paparazzi gave no peace
And brought about this twin decease.

Our thoughts now turn to Wills and Harry
Who must have thought their mum might marry.
But happy ends of fairy tales
Were not for our Princess of Wales.

Her life, of late, was much concerned
With sicknesses that many spurned.
Leprosy, AIDS, she cared so much
That no-one was beyond her touch.

For them, the size of funds she raised
Made us feel humble and amazed.
We must accept that, now, she's gone
But, please, her work must carry on!

G A Isaac

Untitled

It travelled on the wings of time
And spoke of tales untold
Of secret dreams
Pale moonbeams
Memories of old.
It told of love that lingered
Of thoughts that hurried by
A gentle breeze
Heart at ease
A new-born baby's cry.
It sang of hope eternal
The dawn of each new day
Birds in flight
Sunshine bright
Children at their play.
I listened as it whispered
And heard a lone bell toll
Passing years
Smiles and tears
'Twas the sighing of a soul.

Sylvia Tate

KERRY

Long days, and longer nights
I feel stranded on my own
Knowing that something is missing
Like a ring without its stone

Blank and empty-minded
Can't think of what to do
As darkness falls over me
I see and dream of you

Fading pictures in my head
Is all that I have left
Great times and memories
I'll think of 'til I'm dead

Morning comes, I open my eyes
And daylight's peeping through
The sun is out, the sky is blue
But means nothing without you.

Vincent McLeod

Untitled

I woke this morning with a start
And a pounding of my heart
My breath was short I began to choke
Someone's hands were round my throat
My wife began to scream and yell
I'm going to send you down to hell
In heaven you will have no part
You cannot play the ruddy harp
You cannot even dance and sing
Or croon a tune like good old Bing
Tell me why I began to speak
You never lift the toilet seat
So gentlemen when you go to wee
Take care not to end up like me
Pubs and clubs there are not any
And no bloody where to spend a penny.

J Sharrock

THE CIRCUS

The circus is in town
the circus is in town
children running up and down
the circus is in town.

Clowns with painted faces
tigers in their cages
trapeze artists flying up and down
the circus is in town.

The circus is leaving town
the circus is leaving town
children's faces all a-frown
the circus has left town.

Judith Cutter

HOLIDAY BLUES

Goodbyes are never easy,
Feelings torn apart,
Emotions confused inside you,
And the ache of a broken heart,
Goodbye may not be forever,
But it's that feeling, that moment in time,
And when the last touch is over,
The pain remains strong inside,
Thoughts seem to linger forever,
And hopes soon fade in time,
Is there a chance through distance?
Or will the heart go on crying?
Hope is something to hold on to,
But never hold too tight,
Nothing is forever,
Whisper goodbye into the night.

Kerry McGee

MY SON MATTHEW

In 1984 I gave birth to a beautiful baby boy,
Ever since then you've been my constant pride and joy.
We named you Matthew, a gift from God it means,
Strong and upright it really suits you it seems.
I've watched you crawl and then on to walk,
Saying words like 'Mamma' when you first started to talk.
Holding your hand on your first day of school,
Watching you swim in the big swimming pool.
You grew out of your rompers and your baby cup,
You grew so fast I just couldn't keep up.
You're now fourteen and turning into a man,
Making your mark in the world if you can.
Girls will soon be on the scene,
Kissing and cuddling you know what I mean.
You'll soon be off in the big wide world,
Spreading your wings like a big bird unfurled.
In a few years' time you'll be fully grown,
Taking a wife to love as your own.
You'll always keep in touch if only by phone,
Knowing Mum will be there waiting at home.

Linda Woodhouse

AS CHANGEABLE AS THE WEATHER

As changeable as the weather,
Is what people, always say,
And it is, a true description,
Of what our weather is like today.

Some days it's sunshine, in the mornings,
Followed by thunderstorms, at night,
Or else, after breezes, softly blowing,
We get gales, with all their might.

We used to have a new season, every three months,
And in the summer months, we would play,
But nowadays, we sometimes get,
All four seasons' weather, in just one day.

Jean Hendrie

IN ITS SPELL

It's comforting to know
that life goes on
long after you're gone.
And those stars above
still hold me in their spell.
And just one look again
in your direction
then anyone could tell
I'm still in love with you
for your love still holds me in
its spell.
And for every star that shines
tonight
there's a dreamer.
Just one look at me
anyone could tell.
I'm still searching high and low
in familiar places
where we used to go
for your love
because it still holds me
in its spell.

K Lake

TO BE ASHAMED

To never think of others
To never give a damn
To hide away in corners
To be ashamed
To be a man
To take all of the forest
To bring it to its knees
To pollute all of the rivers
To pollute all of the seas
To destroy the ozone layer
To poison all the air
To never think of others
To never really care.

Alan Green

ETERNAL FLAME

This flame that flickers in my heart
Softly, quietly, refuses to depart.
Fiercely sets itself alight
Only my heart is aware of my plight.

The eternal flame that burns for you
I wished you loved me: and that is true.
To feel your warmth and tenderness
Would bring to us togetherness.

He's the copper of beech this eternal flame,
This eternal flame who remains the same.
This eternal flame that my life does touch
This copper of beech that I love so much.

Denise Shaw

THE OLD INDIAN

Huddled round the campfire, in the stark cold light of dawn
The white-haired, aged Indian looked fragile and forlorn
A blanket round his shoulders, an ancient musket in hands
His thoughts still recaptured the treasured memories of the past.

A brave young warrior with paint upon his face
The American Comanche Indian was a proud and noble race
Their lives, their lands, their culture, all of these the white man took.

To leave them smashed and broken like a mighty toppled oak
Now the Indian days are over, no more days to roam the plains
No longer hunt the buffalo, living free as nature's child
Will we mourn their passing, shed a tear for their pain
Or remember them with dignity, these fearless warriors of the plain?

Gwyn Thomas

UNTITLED

Welcome home my darling John your safe return I always long, I always require you through our front door safely more and more, Some of the world's drivers are not safe it is their stupidity you could embrace, You are far too important to risk losing as low as if a bird lost its wing, I adore you deeply for all that you do encouraging my life into a happier view, I appreciate you deeply as you are a great cook and that's with no need to follow any book, I love every part of you through and through not just because you help my life have a positive view, I shall never ever risk losing the best man in my life and you can be certain that I am your ever faithful wife.

Jane Murphy

THIS LAND OF MINE

Sea that bites my island fair
Has it trapped like a snare
Washes her shores with grace
Encompasses with bold embrace
All around this land of mine.
Enhanced by splendid historical legend
Breathing with passion yesterday's fashion
Refusing to be melted by time or erosion
Retreating a little with the centuries
So proud this land of mine
Her hills whisper in melancholy ways
About the past bygone days
The secrets of these shores
Silence would make them mine and yours
But they echo across this land
This land of mine.

David Joseph Burke

BERWICK-UPON-TWEED

Berwick-upon-Tweed
Is the place to
Go
For there is
Always a lot
More to
Do
For me and
You
With lots of nice
Beaches
And lovely sea
Creatures to
See
Including Holy Island
Too.

Coleen Bradshaw

Don't Quit...

Like a flame flickering upon a match,
in a deep, intensely dark cavern,
a glimmer of hope flutters in the cold breeze,
like a caged bird flutters its wings,
as it struggles to break free from its incarceration,
but the deeper and denser the blackness becomes in the cavern,
the weaker the flame becomes,
until it's snuffed out altogether.

Life's like this:
the deeper the despair, the depression,
the profounder the misery,
the weaker the glimmer of hope becomes . . .
from the dismally grey day,
to the deepest and blackest night, where even shadows die.

What hope is there for the flickering glimmer of hope?
Never quite strong enough to make a lasting impression,
just enough to give you your bearings,
so you can tell what direction you have to travel in,
but never strong enough to guide you through the tunnels,
to show you what pitfalls lie ahead,
and what obstacles lie strewn in your path,
so you're always stubbing your toes,
feeling blindly with your outstretched hands;
and this must be how a blind man feels,
tentatively feeling his way through life,
reconnoitring his way around a strange room.

So how do you prevent that beautiful, slender, glimmer of hope,
that spark of life from being extinguished?
You tear off your shirt, and hold the torn edges aloft,
above the slight flame,
until the fabric catches alight,
until you find your way out of the cavern;
better a man for the experience, stronger for fighting,
more resilient for not quitting,
and that must be the number one rule in life:

preserve yourself at all costs,
persevere through the quagmire that you wade through,
do not quit, retain your dignity and pride,
no matter how hard the fight is from the onset . . .
roll with the punches, go with the flow,
but of your confidence, your ego,
your dignity and pride - don't let go.

For how can you hold your head up in pride if you give up?
How can you retain your confidence and dignity if you quit?
How battered and bruised will your heart and ego be if you cared less?
So wise up, take your glimmer of hope,
and create a raging inferno in your heart and mind,
let your spirit fly high above the earth,
and if you become earthbound once more,
whatever you do - don't quit!

Gary Hayes

VICKY'S LEGACY
(Tribute to my granddaughter)

I am your favourite Renoir,
Your sunflower Gauguin print,
I am your walks in cornfields,
With long flowing hair,
I am your rides on horseback
Your laughter in the rain,
I am your favourite musical,
Your remembered 'Casablanca',
A treasured piece of Coalport,
I am the hand that reaches to touch the children,
The eyes that remember the poverty in the streets,
The finger that never points to rejection,
I am your new house,
Your designer interior,
I am your silent telephone,
Talking happy talk,
I am your houseplant,
That keeps on growing,
I am now all the things I want to be,
I have a degree of life!
I am your inner strength,
Your warmth,
Your care, comfort, and kindness
I am your legacy of love eternal,
So please be happy, forever for me . . .

Magarette Phillips

WINTER

Winter's here once again,
Bringing snow, sleet and rain.
Day is shortened,
Nights grow cold,
Stars scattered above,
Like pieces of gold.
Rooftops, all covered,
Snowdrifts of white,
Glistened on windows
Ice crystal-bright.
In the depths of the valleys
Small creatures they sleep.
Huddled up safely,
From the cruel winter's bleak.

Sheila Farrer

TIME OUT

Take time to smell the roses
As you go along your way
Find the time to look around
Throughout your busy day
Our world is ever-changing
With the problems that it poses
Look after one another and
Take time to smell the roses

Take time to smell the roses
Give yourself a treat
Create a space just for you
To rest your weary feet
The basic needs can sometimes be
Forgotten as day closes
What really is important?
Take time to smell the roses

Take time to smell the roses
With your children when they're young
They fly the nest before you know it
Leave no song unsung
Listen, love and guide them
Even when you face opposes
Best of all ensure that they
Take time to smell the roses

Take time to smell the roses
Though it's harder in these times
Of drug abuse, violent wars
And cruel heinous crimes
Answers are forever sought
To end all things atrocious
We hope and pray and on the way
Take time to smell the roses

Gloria Aldred Knighting

Windows

Let open be those windows of your mind,
You have met someone of your kind;
That a brighter world through those windows see,
Without dark or sorrow your world will be.

Of an older age, a grandma you may be,
Though eyes of a child you will always be;
For love of them you falter not,
In their turn will they forget you not.

Whilst angels their faces with hearts open wide,
For dearest Grandma their love will not hide;
No burden of care, but a joy that's free,
Keep open those windows that you may see.

Your life full and rich, those children mean home,
Be not distressed, you walk not alone;
To greet with you, your smile, my pleasure
If help your need, command it ever.

S M H Barton

SOMEWHERE ... SOMEWHERE ... SUNSHINE

Whenever there is summer and sunshine
I am carried away ... I begin to wonder and wander
to Eastbourne ... I cry Eastbourne ... I dream Eastbourne
I do not remember ... recollect ... except fine beaches ...
 clean and tidy
how and why I went to Eastbourne in the first place ... But ...
everything was clean appealing stimulating and attractive over there
 for me
all around there I felt at ease at peace then and there with myself
within myself, in front vast quiet ocean sea, just keep looking at it
I felt so at home at ease feeling that even I prayed to God silently
if you do not recall now then please let me spend retirement
 days here ...
whatever there may be left out of my life
my livings of every days every moments life's livings
curiosity made me communicate with a person ... whatever came into
 my mind
The leading query was how is the climate over here
as I am struggling ... surviving on medicines so many
I raised this question to a woman or a man ... I do not remember,
 I cannot recall
and also how and why we began communicating in the first place
the reply was that in the climate of this place
one develops arthritis, I became withdrawn within myself
it saddened my soul I went with an acquaintance next time
once again that I might not remain to the age of sixty five years
still ... in spite of all this I visualise, I cry, I feel
Eastbourne ... Eastbourne ... fascinating, charming, enchanting,
alluring ... clean and tidy all around everywhere ...
 can I call you mine
do you want me over there day and night
till I live in and out remain alive ... before I part for the next life
I accept ... I admit I have not confirmed my worries
with Eastbourne County Council as I am still fifty nine years
I have no finance to enable me to do it.

Ghazanfer Eqbal

AND *STILL* THE BLACKBIRD SANG!

A dreary day in 'flaming June',
high winds with lashing rain,
sodden, sad, the garden lay,
submissive in its pain.

The icy wind raged through the trees,
their branches bent awry;
flowers, blossom tortured
beneath a leaden sky.

Then, spite of Nature's angry mood,
a joyous sound was heard,
mellifluous, sweet carolling,
full-throated, rich aubade.

A lonely blackbird piped his song,
defying wind and rain,
impassioned, lucid cadences
repeated yet again.

What cause of joy inspired his song
I cannot ever know,
but thank him for the lesson taught
in helping me to grow.

When life is hard and outlook bleak,
I shall recall that morn
when blackbird sang, with courage high,
a joyful song at dawn.

Geraldine Squires

LIVING WATER

Time's water trickles down life's stream.
Tells a story spins mind's webs or shapes a dream.
For each of us a different good or bad happy and sad.
Events in each babble, bubble and eddying flow
Swirling gushing fast and slow
Calming slowly as you get to know
This water wears away trouble's stone
For life's cutting edge its flowing channels wet the hone.
Sharpens up perceptive eyes to view life's scene.
Helps value what has flown and just what might have been.
Reflect God's sunlight silver/gold.
Will fortify the faith in young and old
Rejuvenates your spirit but
Listening to the ripples say a prayer,
For the water in life's stream will not always be there
Its course will change and others' lives will rearrange
Then if listening to stream's babbling voice,
Each human spirit has free choice
To see this living water as a sign
In the overall and great design.

R Powell

A Word To A Fellow Poet

You are only one among worldly crowds -
A king yourself, with leaves of oaks and laurels for a crown
Upon your unsubdued brows,
Enthroned upon the throne of your own,
The crowds don't recognise your insights -
Your intellect to most of them unknown,
But *you - you* are an unquenchable light,
The torch of God, a wisdom of renown.
Let them think you are to them a burden -
But you, lift your head high, and write in a verse story;
For the world is full of ignorant and foolish men
They shunned reason, and trampled down glory.

Stanislaw Paul Dabrowski

A Global Freethinker

All the brightest thinkers in the world,
Are Cosmic Freethinkers like me.
And they are all Republicans
For the 'Democratic Society' to be.

We do not have a warlord,
To arrange the kind of wars,
That we have seen in Jugoland,
Or on the Arabs' distressed sand.

Every citizen is special,
A unique Cosmic unit planned,
To think and vote for altering,
The way we design our global land.

'To be, or not to be' is settled,
Within every single mind
And we recognise no pulpit-man
Who tries to tell us what to find.

All *gods* are just invention,
To feed some monarch's ego now,
For a warlord's plain intention
Is to rule a roost somehow.

But Democracy will foil them,
And every evil they have planned
To miseducate the people,
On our hallowed global land.

The sectarian wars are ending,
A *new era* is at hand,
Beginning after 1999
To make *the world, a happy land!*

The *world of many nations,*
Must be *condemned* implacably,
To make way for *Cosmic welfare,*
A World of *Freethinkers* living the *Glasnost Way.*

Edward Graham Macfarlane

SOLITARY SOLDIERS

The sky is black as tears fall down
onto the forgotten grave;
just another mother's child who gave
his life to save,
Saved what they all believed in, this
land we call our own;
they went together, fought together,
but many died alone.

Nature salutes their memory with a
wreath of fallen leaves;
the sun that shone when they died, now
shines at all they achieved.
I salute you too; I think of all
that you've done,
Although I never knew you, I remember
the price you paid for the prize you
won.

Iain West

THE ROOK

Dead he lies beneath the tree,
Once in flight so bold and free,
Beak and claw his only tools
Yet nobler than we human fools.
Soaring with the winds of earth
Above all mortal woe or mirth.
Freedom of spirit have we all,
Till we reach the last fatal call -
So why should we, more than be
Hope for immortality.

Sheila Aikinson

UNSUNG

She was here, a while, quietly,
Among the heather and the little streams,
Dancing in the sunbeams of childhood,
Kissing the buttercups,
Living out her little dreams, quietly.

And later, with the fearful shadows falling,
Going on, quietly, to womanhood and mothering,
Guiding little feet,
Always, always down the middle road,
Searching for buttercups, quietly:

And when the history of these times, this place, is shown,
Her name will not be there
Among McGuinness, Adams, Wright, McMichael, Stone . . .

And when her friends and family go,
Who will know
That she was here, a while, quietly?

Ann Stewart

THE END

Now is the time for hatred to end.
For that ground axe, no more metal will spend.
And he who says, he walks with the Lord,
Gives up violence, and throws down the sword.
Sometimes man's brothers can be right
If you could see, in a different light.
Oh! It's too late when they carry his body away
For only his mother will kneel and pray.

R Wright

WITH SILENT TEARS

As I sit here my mind's in torment
Thinking of another,
Wondering if 'the other' is sitting too . . .
Thinking of his mother.

What sadness lies within my heart
What sadness as well as joy
My heart is pining with silent tears
'Til the time I see my boy.

My boy! Oh he is a man to all, but me;
To me . . . he is my son
Sometimes, just sometimes I wish the past
Could be acts to be re-run.

Is living a game or is it a play
Or is life just hellish fate?
Whichever it is we must all agree
That love must be the bait.

Love is a cruel and beautiful thing
It can bring joy and pain as one,
But no matter what's in store for me . . .
I still long to see my son.

D McKenzie

VIAGRA FOOLS

I firmly believe in Viagra.
It's hardened my resolve.
At one time I had a small problem.
But now the problem is solved!

They used to say a good man's hard to find.
But now it's the other way round.
They now say a hard man is good to find
So I am duty bound.

I say 'Let's stand up for Viagra.'
It's literally a 'swell pill'.
Most sixty-year-olds said it points at the floor.
Now it points at the windowsill!

So let's raise a cheer for Viagra.
Impotence, a thing of the past.
Hang a banner on the flagpole.
We no longer need fly at half mast!

But I'll end with a small note of caution.
There's always a downside you see.
It takes a long time for the effect to wear off.
You must stand on your head for a 'pee'!

Roger A Carpenter

I Love Thee

Love's defined in many ways,
An emotion with many meanings.
Eaglistic love of power,
Man's objects, but just dreams!

Love for parents, or a child
Different levels to be treasured.
But love for a partner,
Beautiful magical moments unmeasured!

Love for the beauty of this world,
So everyone can live and be free.
Him upstairs sends His true love,
Why I return my love to Thee!

Ann Beard

THE PERPETUAL GRUMBLERS

Never a moment goes by
When heartfelt grumbles
Are not spoken by perpetual grumblers
Who love nothing better
Than to voice their opinions
To the letter to their companions
After a day's work has been done
Every gone-by day the same old story
The dinner was cold at the usual cafes
My wish is that these kinds of people
Leave their grievances behind in self-pity glory.
Those Taffies who live to grumble their way through life
A picture of heaven-sent misery
Yet, they dwell in a haven of bliss
Being so happy to make people
Hiss with rages
They are not even glad to enjoy their wages
That they are entitled to in spite of their woefulness
May we narrowly escape their company
And be with people who
Are jolly and bright
Yes, let's say 'boo' to the
Everlasting miseries who
Take to the streets day and night!

Alma Montgomery Frank

THE LIGHT

See the light.
See the dawn.
The need to work.
Guidance from above.
The real me. The real you.
Real society.
The real world.
Know enlightenment!

Keith Murdoch

MY LORD ABIDES HERE

With the fallen eventide
I pray my soul with the Lord abide
At the closing of the day
For my safety to the Lord I pray.
In my home I cannot hide
For my Lord is by my side.

He reaches out to save
Lifts the dead from the grave.
Power over the devil's sting
Relief from all pain He did bring.
He will always care
In my home my Lord is there.

When troubles start to show
God's love will start to grow.
When your enemies gather round
God's love can soon be found.
In my home I can see
My Lord does abide with me.

Colin Allsop

LOVER'S RETURN

In the rays of the sun sleeps a maiden, her
Golden hair spread on grass so green
As she lays there by the river she dreams of
Happy days of yesterday.

This girl, this beautiful lady, a princess of long ago,
Dreams of riding upon her snow-white stallion,
With her prince who loves her so.
Her golden hair streams out behind her
Her laughter fills the air
With her handsome prince beside her
She rides as fast as the wind.

She dreams of his kiss upon her lips as sweet as
The honey from the bee,
And of his eyes as blue as sapphires, and a love
That's oh so true.
But as she dreams this beautiful maiden, a tear
Slowly trickles from her eyes,
Because she knows when she wakes, her love is not
There beside her, but far away in the Holy Lands.

But as she sleeps there beside the river, in the
Distance a horse appears, and sitting upon his back
Rides her lover returning home to her once more.

He sees his fair young maiden lying there asleep in
The grass so green, her lovely hair spread out around
Her like strands of burnished gold.

He sees the tear upon her cheek and kisses it from
Her face. His lady thinks she's still dreaming as she
wakes and sees him there,
Until she tastes his sweet kiss upon her lips and sees
The smile upon his face. He lifts her upon her
Snow-white stallion and together they ride like
The wind, and if you listen you can hear her
Laughter, happy with her handsome prince
Once again.

May Strike

WHAT WE HAVE
(Remembering Roger, 1991-1998)

What have we now?
Did you ever lay within our arms
and charm our hearts onto our sleeves.
You gave us the strength to carry on.
You were the faith and we did believe.
We prayed you might live forever.
On a rainy day, your eyes shone bright,
and rainbows rose and bowed.
You were our pot of gold.
A priceless treasure; perfect boy,
you brought us more than we could have dreamed.
With you, our lives had meaning.
You were our pride and joy.
Did we ever find a cause to scorn?
You could never fail to lighten hearts,
you'd smile, and then you'd caper on.
But what have we, now you're gone?
You were there to chase black clouds away,
you saw us through the storms.
The angels cried the day you were born,
for they waited long to take you home.
Carry us with you, for you hold our hearts
as sorry heads hang low.
A smile might play upon our lips,
for even sad hearts know that you still shine.
In every thought you yet live on,
you colour dreams and fill the skies.
Each memory brings you back to life.
You can still bring laughter from our sighs,
even when tear-stained eyes are sore.

Now, we have the strength you gave,
you still have that power; to save our lives,
and we'll carry your light, for ever more.
We shall always love; you will never die.

Heidi Michelle Lambert

BUILT-UP STRENGTH

the weather a killer
so some find it
the deadly deadly weather
can kill or injure
some poor victim
keep clear of the
high strong winds that
blow in with force
with force and all
that built-up strength
no the killer nature
has old hands still
we sense all that
so do the others
who often see it
all happens so fast
never say nature is
only often so calm
it can change and
it can destroy and
take more than just
one single young like
in a tempest storm
you pay a high price
even to live or even
to die if it's been
decided to be so
and that's the way
the one single way
around so much encountered

Richard Clewlow

YOU'VE GOT SOME DRINKING TO DO

Your angry little world will soon reject you
Along the road you're seeing all the signs
And then you'll find that all your friends neglect you
With every note you'll read between the lines.

You'll soon be looking back on life in sorrow
The days are getting darker one by one
And though you used to sneer about tomorrow
Tomorrow soon will be the day that's gone

When the joys return to ashes by and by
When your temperature crashes don't ask why
You've got some drinking to do
But the price of your bottle is overdue

You say those stupid things to get reactions
You think it's clever now but just you wait
And pretty soon you won't be an attraction
And you'll start thinking then when it's too late

You've got some drinking to do
But the price of your bottle is overdue

M Shimmin

NOT ME!

I don't know why
But I get so tired of being
Somebody who isn't always the real me
And there are days
I don't want to face reality.

I've been doing this for some time
So why do I feel tired of being someone whom I'm not
I'm trying so hard to try and be
Someone who I'm not meant to be.

I'm putting on a show
To impress others
But now I'm too late
To show how I'm meant to be
Not someone else
That they can't see but me.

I try to give them
Everything they want from me
But I've tried to be the real me
But that didn't work,
So I'll have to be somebody else, *not me!*

Marc Hambly

LIFE

Life turns,
Hearts break.
People change,
But no one waits.

Friends go by,
Quick and fast.
So hold them close
For memories last.

Changing times,
For better or worse.
Whatever happens,
The future turns.

Love what's here,
Not what's gone.
Make the most
Of every song.

Live life to the full,
Whatever it be.
For no one knows
What waits for thee.

Joanne Ellis

PAINTING PICTURES

How often do we see a scene
and try to capture it on paper
Out come the paints, water or oils
We try and try, but after all our toils
That picture we cannot recreate
Why? It's there, but we cannot transfer
from mind to reality, reality to paper
What is wrong? Why, oh why, does it happen
 or is it me?
Is it my mind that doesn't work?
How I'd love to see the finished scene in all its glory
Maybe one day I shall - when my mind
works as it should, or could
and just put that wonderful scene
 on paper.

Olive Wright

A New Day

Suddenly, in the night,
That solitary light
Planet Venus
Says goodbye;
While farther to the east,
Her distant cousin seen the least,
In the dawn's blush
Starts to leave us
And to die.

Tom Ritchie

SKETCHES

Today is the day to be happy.
Tomorrow may be too late.
Only the present is certain
Foolish are those who would wait.

Make use of the blessings God gave you
Or else He will take them away.
Remember things fade rather quickly
Enjoy all your gifts while you may.

Happiness stays but a moment
But every few realise this.
Seldom can people recapture
A moment of heavenly bliss.

So it is I who sends this message
To all who tread life's toilsome road.
Live every day to the fullest
It may be the last episode.

William Price

TO AN INJURED SON

Will you rise again at Easter, strong and free?
Your precious speech restored, your strength renewed?
Will you walk tall, and walk away from me?

Eyes touched by grace may once more clearly see,
And weakened limbs can yet grow strong again.
Will you rise again at Easter, strong and free?

Or has such hope become a fantasy?
The cross your one and only portion now,
Will you walk tall, and walk away from me?

Perhaps one day you'll know why this should be,
Your agonising questioning be stilled.
Will you rise again at Easter, strong and free?

Hope or despair, delight or misery,
Jumbled, unanswered questions, silent fear.
Will you walk tall, and walk away from me?

Day after day I question fearfully,
The blighted years that now may lie ahead.
Will you rise again at Easter strong and free?
Will you walk tall, and walk away from me?

Joan Isbister

MY TRUE LOVE FOR EMMA

Emma, Emma my heart is in trouble but you'll never know how much
Since we parted I have not been lucky.
I did start again but it lasted only a couple of weekends!
I can't love anybody else you were the first love that I ever had
and for me you are the last. So I beg you to come back to me.
I was very stupid to let you go but now please let me know if you
still have a little love for me, please do not draw away.
Nobody can love you like I do. You and I will make the biggest mistake
of our lives if we don't patch up and forget the past! If you and I do not
meet again I shall think of locking myself in the house of lunatics
before I marry someone else that I have no love and interest for.
Emma, this is my dilemma; you can help, or you can destroy both your
and my love but you can't kill my love for you! Even when I go down
the peat. My love for you cannot be defeated! I beg you for the last time
my heart is open for you to enter before time for you and me runs out.
My true love for you will never die.

Antonio Martorelli

Q10

has rescued me
radio voices
attacked and criticised
for many years
aeons of personal time
transmission
rate increase
in synapses, neurones
of brain
and I am free
peace and quiet
the co-enzyme works
Krebs cycle dominant
free at last
now to undo
the damage done.

Jean Mercer

ELEVEN THIRTY-THREE

For I am just a million miles away
And yet I feel you close to me.
That empty feeling mellows gently,
As I remember how things used to be.
This night as family, we are far apart
Each on a separate road
But in my prayers are each and every one of you
No sleep, as precious memories unfold.
Midnight approaches, passing of another day
Soon the dawn will break, maybe - the sun,
Problems recur, relief of them I pray
Be brave, new challenge has begun!

T G Bloodworth

A Donation We Give

So 'wonderful a gesture', it can be,
When we ordinary people support a 'charity',
In life's dependency, 'hardships' are found,
What charity we can offer, is shared around.
Whilst it must be better, to give than receive,
Care must be taken, against those who deceive.
In unstable countries, economically unsound,
Never enough charity, can be found.
Poverty, disease, starvation and drought,
A desperate fight, to live their life out.
Those 'pence' we gave, builds up to 'pounds',
And gives comfort, where those 'deprived' are found . . .

Brian Marshall

My Dungeon

This dungeon is my own despair
A dark and dank, unhealthy place
Its misery I cannot share
So loneliness is what I face
Time is unimportant here
Escape is but a wasted thought
The dungeon master, my own fear
He laughs to see me so distraught

There are no windows and the air
With memories is stale and thick
I believed you used to care
But my mind played the cruellest trick
My prospects look extremely bleak
No end to this is there in sight
Cold and grown extremely weak
Not knowing if it's day or night.

Kim Montia

ROAD WITHOUT END

There's a highway in our life span
Which we walk along each day
Where a signpost points to knowledge
Many unknown miles away.

It's a long and tedious journey
With a steep hill and twisting bend
And though we tread it many years
It never seems to end.

We first trod it in our childhood
With our guardians by our side
And the help of Mother Nature
To add vigour to our stride.

Then walking on to schooldays
To profession, craft and trade
To face the many pitfalls
Which man himself has made.

But as the years roll onward
There comes comfort to discern
That for every mile of walking
There's been something new to learn.

David Goudie

SAMUEL THE OCTOPUS

Samuel the octopus is green as green can be
He enjoys himself greatly as he travels through the sea
The pretty coral makes him smile
The giant squid stops to chat a while
And of all the creatures that he could be
He thinks being an octopus is very good indeed.

Lord Ciaran D'arcy

PRICELESS GIFT

Costing nothing but worth a lot,
It might be the only thing you've got.
You may have nothing in your purse,
And feel things couldn't get much worse.
Worth nothing till you give it away,
Makes a difference to a bad day.
So natural from a child,
True love they can't hide.
From a baby, so pure, a gift,
Gives your heart that special lift.
On the face of the lame or the blind,
Making you feel humble, and should be kind.
Not just restricted to the young,
On wrinkled face with toothless gum.
Encouragement, reassurance, gratefulness, pleasure,
A tonic, an untold treasure.
The priceless smile
Making life all worthwhile.

Sally Slapcabbage

DO YOU KNOW?

From heaven to earth from whence He came,
Healing the sick and the lame, turning water into wine
These things gave Him fame.
Learning right from wrong,
His name goes on and on all in song.
Life was short for a man of such miraculous deeds,
Nailed to a cross without sowing any seeds.
Hanging on the cross and in such pain,
They sealed Him in a tomb and again He rose,
 forever to remain.
But why do we adore, love and pray to a man of the past
 and never knew,
Well I don't know, do you?

Roy H Fox

THE CASTLE

I closed the door to the castle,
Secured it, with a lock.
No-one is going to get in there,
It doesn't matter if they knock.

The rooms adorned with loveliness,
Forged with love, were a special place.
No other rooms more beautiful,
Few others, embraced, such taste.

But now the splendour is sealed,
Tarnished, degree, by degree.
From those who caused violation;
Deep, in the very heart of me.

The castle's treasures are locked forever.
No-one will ever gain access.
For protection will be the deterrent
From those, who seek to oppress.

The castle is in the heart, of all that I am.
In innocence, the treasures do lay.
But no-one was worthy of the beauty,
So for safety, I locked it, away.

Janet Parry

MEMORIES

I remember the world beginning,
The first bees humming and the first birds singing,
The first sun shining on a dark, cold day,
The first little fox cubs coming out to play,
The first breath of springtime and the buds on the trees,
The first fluffy clouds that came floating on the breeze,
The first shiny dolphin leaping high as it could go,
The first little flowers growing fast as they could grow,
And then as everything was perfect as everything should be,
I looked from the high cliff down to the sea,
And what did I see walking proudly on the shore?
My first glimpse of *Man* coming along to ruin it all!

Sharon Davies (13)

A Special Party

The drivers who brought them, knew of their plight,
It was clear for these children, each day was a fight,
So this party was organised, for children in need,
Thanks to the efforts of many, it was sure to succeed.

The children arrived, some with tears in their eyes,
Sad, pale, staring faces, to us no surprise,
They took off their coats, as the music blared out,
For a party to remember, without any doubt.

There were hats and balloons and good things to eat,
An entertainer called Johnno, to add to the treat,
Lots of fun and much laughter and some magic too
Took for granted by others, but which they rarely knew.

They danced, played some games, it was now plain to see,
Their expressions transformed, were turned into glee,
Joined together in conga to dance round the room,
There was hope, there was life, there was no trace of gloom.

The next thing that happened, someone opened the doors,
And into the room, walked their own Santa Claus,
With goodies and presents and gifts in his sack,
To make up, in some way, for what these children lack.

And now it was over, many wanted to stay,
To dance and have fun for the rest of the day,
But it was time to go home, before it got late,
Remember James? Yes, he said that the party was great!

Sheila Ingham

HALCYON DAYS

Bacon, eggs and skip to school,
For discipline with iron rule.
Chance of being dunce remote,
3 Rs are taught by way of rote.

Schooling over, job awaits,
First week's pay exhilarates.
If you want a change of job,
Plenty more and few more bob.

Around the family, life is based,
Strict, upright, proud, chaste.
Its obligations undertaking,
Generations in the making.

Crimes are few and far between,
Because a policeman's often seen.
Miscreants receive a clout -
Instant justice carried out.

Church and chapel overflowing,
Summers long and winters snowing.
No-one says 'I'm alright Jack!'
Happy days - let's have them back.

Gordon Haines

ON A COOL WINTER MORN

Shafts of light through the trees
On a cool winter morn.
Birds are singing their sweet song
Heralding in another brand new dawn.

A spider's web picked up in the light
With work so intricate who gave it insight,
To weave and spin in a painstaking way
Then to rest awaiting for its prey.

Seagulls swooping on the crest of a wave
Seeking for food as the tide changes place.
The robin redbreast sits in wait
Territorial who guards and baits.

As glistening frost their patterns do make
Covering the ground a silver shimmer is found
So white and still glistening in the Father's will
All of this can be seen, on a cool winter morn.

Who wrote these laws in man, creature, beast
Nature providing its creatures with a feast,
For as night follows day with winter on the way
Father God teaches His creation His ways.

Lillian R Gelder

WICKED WAYS

Look at the world today
It is a crazy place I have to say.
Look around and what do you see?
People living in fear, poverty and
 uncertainty.
Drug dealing and stealing
Troubles and hardships
Windows smashed with bricks
Vandalism and socialism
Crime and doing time
Youth forget school
Time for mob rule
It's all the rage
Should be all rounded up and
locked in a cage.
Raving and misbehaving
Uncaring and swearing
Society
It's all a terrible pity
It's the same in the country,
The towns or the big bad city.
Wicked ways
Here to stay
Unfortunately for always
The world today
Is a crazy place going the
wrong way.

A Khan

THE OLD COTTAGE

The house was old, the walls are bare,
A lot of hard work lay ahead,
It would take a lot more than a wing and a prayer,
Before I move in, with my four-poster bed.
Dreams of oak beams and an inglenook fire,
A kitchen all spacious, with cupboards in oak
But right at this moment it looks very dire,
At least there's a bath so I can have a good soak.

I'll put in lattice windows, all cosy and neat
And have large Persian rugs on the floor,
In the lounge I will make a nice window seat
With a cupboard, where things I can store.
This little old cottage was all derelict and cold,
It was a dream come true, when to me it was sold.
I am sitting here now with all the hard work done
In my garden of roses, enjoying the sun.

G P Silver

SUNFLOWERS

I was walking along a country lane,
I saw sunflowers swaying in the sun.
The middles as brown as a bun,
Bright yellow and orange petals around dark faces.

Long, spiky stems,
Standing straight and proud,
Drifting in the breeze holding their heads up high,
These kings of flowers reaching up to the sky.

Petals soft as cotton, splashing with softness,
Swooping gracefully and tickling your eyes with amazement,
They come to life marching in the field,
Watch them fade against the sunset.

Sam Edwards (9)

OUR WORLD

Open your eyes, look and see the world that we've destroyed.
Close your eyes and think about the Gods that we've annoyed.
Our selfish ways, untidy habits, only looking out for one.
So blind that we do not realise the world will soon be gone.
'So what,' we say in a selfish tone, 'we'll be dead by then,'
With money burning through the pockets of impatient, uncaring men.
And hypocritical Members of Parliament, demand that we not drive,
With three cars and massive wage they struggle to survive.
We're taught to battle for money and power,
I just wish that we could see,
Without possessions, money and power how much better life would be.

Alan Brooke (17)

POETICAL ASPIRATION

How I yearn to be a poet
To put tales down in rhyme,
Descriptive stories, but oh!
It must take no end of time.

Just thinking how to start it,
Wondering what to write,
And what about a middle bit,
The verses to unite.

I haven't got the know-how
To do all that, I think
I'll leave it all to experts now
And save my pen and ink.

P Openshaw

Mulling

Spring shall rise in a sea of colours -
Buds open their arms to embrace the mulling.
More in abundance than a crowd to the mystic -
Nature's inbreeding bares the distinguished.

See the stalks, as they lean on the breeze,
Changing shape - surreal - yet at ease.
And all their names that pass from our mouths -
Mean nothing to them - as they bloat in their slough.

Their casting enthrals, as they all consummate -
Uninhibited - unquestioned - they have no disgrace.
Yet wait, I see the roses blush, the pansies drooping coyly thus -
Broom bending low in reverence, and willow weeping without fuss.

Spring entwines the spores, and murmurs,
Into being - in a sea of colours.

Tina McCarthy

SUBMISSIONS INVITED
SOMETHING FOR EVERYONE

POETRY NOW '99 - Any subject, any style, any time.

WOMENSWORDS '99 - Strictly women, have your say the female way!

STRONGWORDS '99 - Warning! Age restriction, must be between 16-24, opinionated and have strong views. (Not for the faint-hearted)

All poems no longer than 30 lines.
Always welcome! No fee!
Cash Prizes to be won!

Mark your envelope (eg *Poetry Now)* **'99**
Send to:
Forward Press Ltd
1-2 Wainman Road, Woodston,
Peterborough, PE2 7BU

OVER £10,000 POETRY PRIZES TO BE WON!

Judging will take place in October 1998